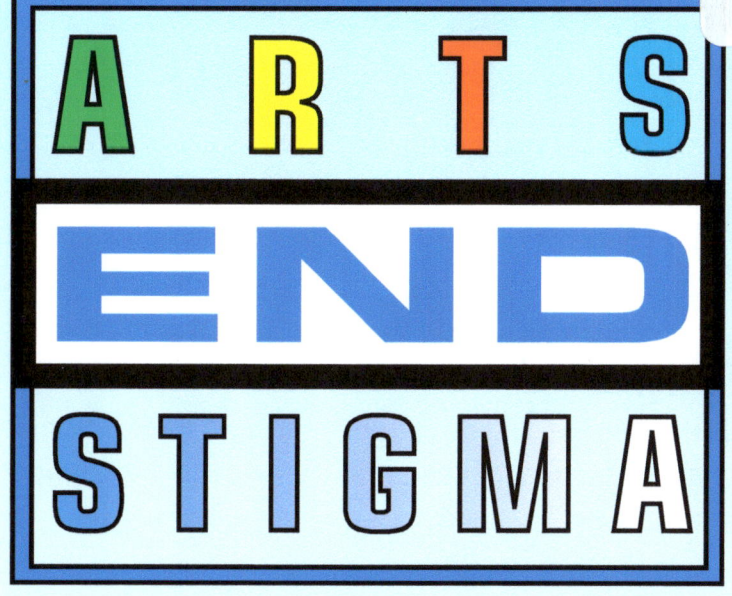

Through a series of free arts events, including exhibitions, hands-on workshops and plays, "Connect Heal End Stigma" shines a light on issues of mental illness, stigma, wellness and recovery, while showcasing and cultivating the talents of the mental health community and general public.

Events will promote a message of community building and stigma reduction, serving as a catalyst to enrich the lives of all participants

Funded by the County of Orange Health Care Agency, Behavioral Health Services, Prevention and Intervention Division, Mental Health Services Act / Prop. 63

Copyright © 2013
Orange County Center *for* Contemporary Art
All rights reserved.
ISBN-13: 978-1491073308
ISBN-10: 1491073306

 EXHIBITS

"Connect Heal End Stigma"

Celebrates mental health awareness and community through connection, featuring original artwork by professional artists, who are also: mental health advocates, community builders, arts educators, and/or family members and /or are persons diagnosed with a mental illness. Through the observation of these courageous and honest works of art, which reveal personal stories and experiences, exhibition viewers will learn about persons with mental illnesses, the stigma they have faced and the many roads of advocacy, wellness and recovery.

Orange County Center for Contemporary Art: 117 N Sycamore St., Santa Ana, CA. 92701 • OCCCA.org

WORKSHOPS

Free hands-on workshops in fine art; creative writing / poetry; dance and music will be offered at OCCCA. Workshops will be facilitated by professional artists and include the discussion and creation of artworks reflecting on themes of stigma, wellness and recovery. This experience will enhance the lives of participants, helping to reduce stigma, anxiety and stress and raise self-esteem, while providing a sense of joy and productivity derived from a positive access to their imagination and the healing process of creativity.

Orange County Center for Contemporary Art: 117 N Sycamore St., Santa Ana, CA. 92701 • OCCCA.org

THEATER

The feeling of separateness for those diagnosed with any level of mental illness can be acute and the thought that one is entirely alone can be difficult, and at times extreme. Through a compelling script of deeply moving vignettes, the raw, honest and poetic tone of *"I Live In Your World"* gives voice to a marginalized population of persons with mental illness, communicating personal stories and messages that engage the audience on an intimate and universal level

Grand Central Art Center, Theater: 125 N Broadway, Santa Ana, CA. 92701 • grandcentralartcenter.com

Connect Heal End

These events are dedicated to the service and memory of Artist, Educator, Mental Health Advocate Janice DeLoof

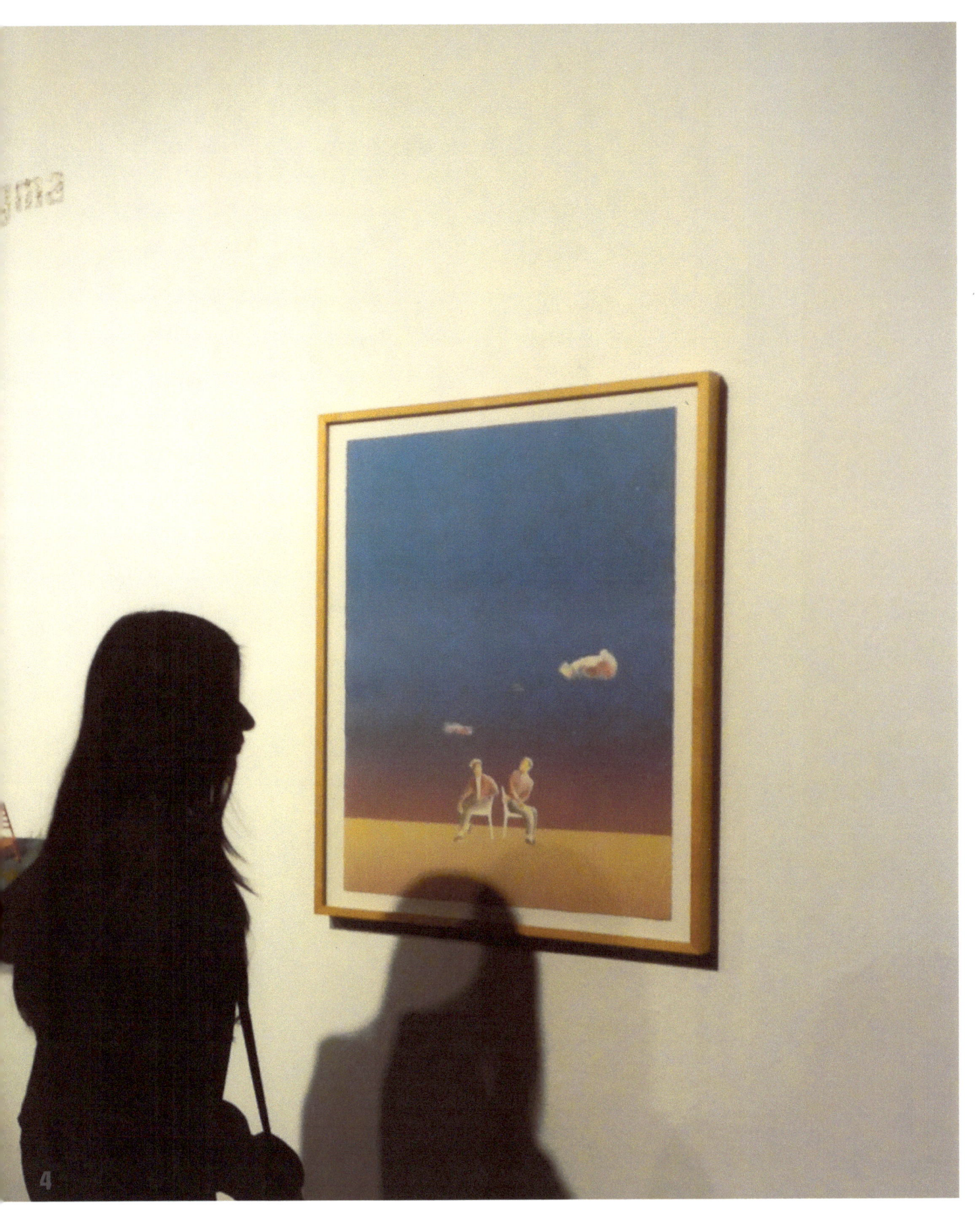

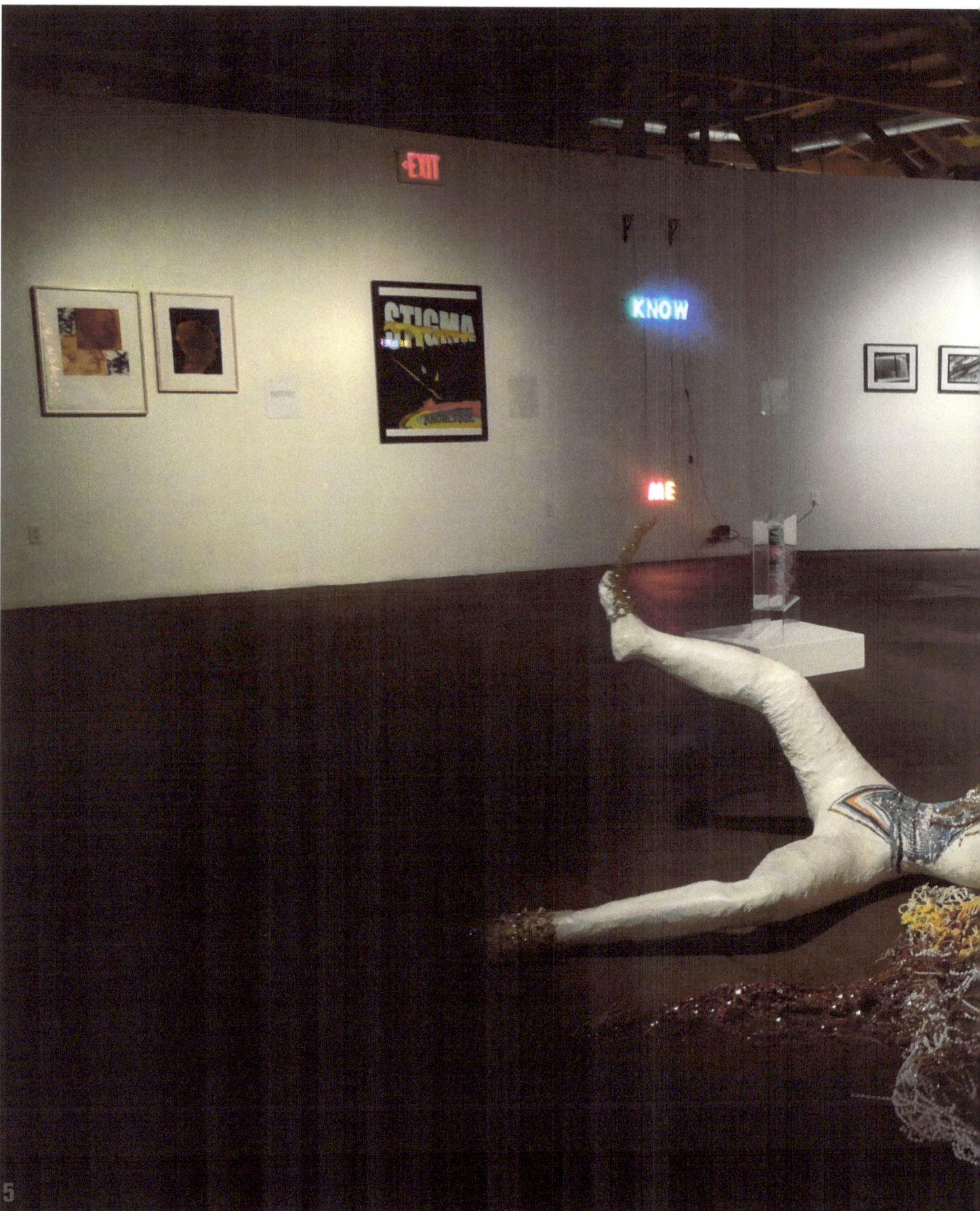

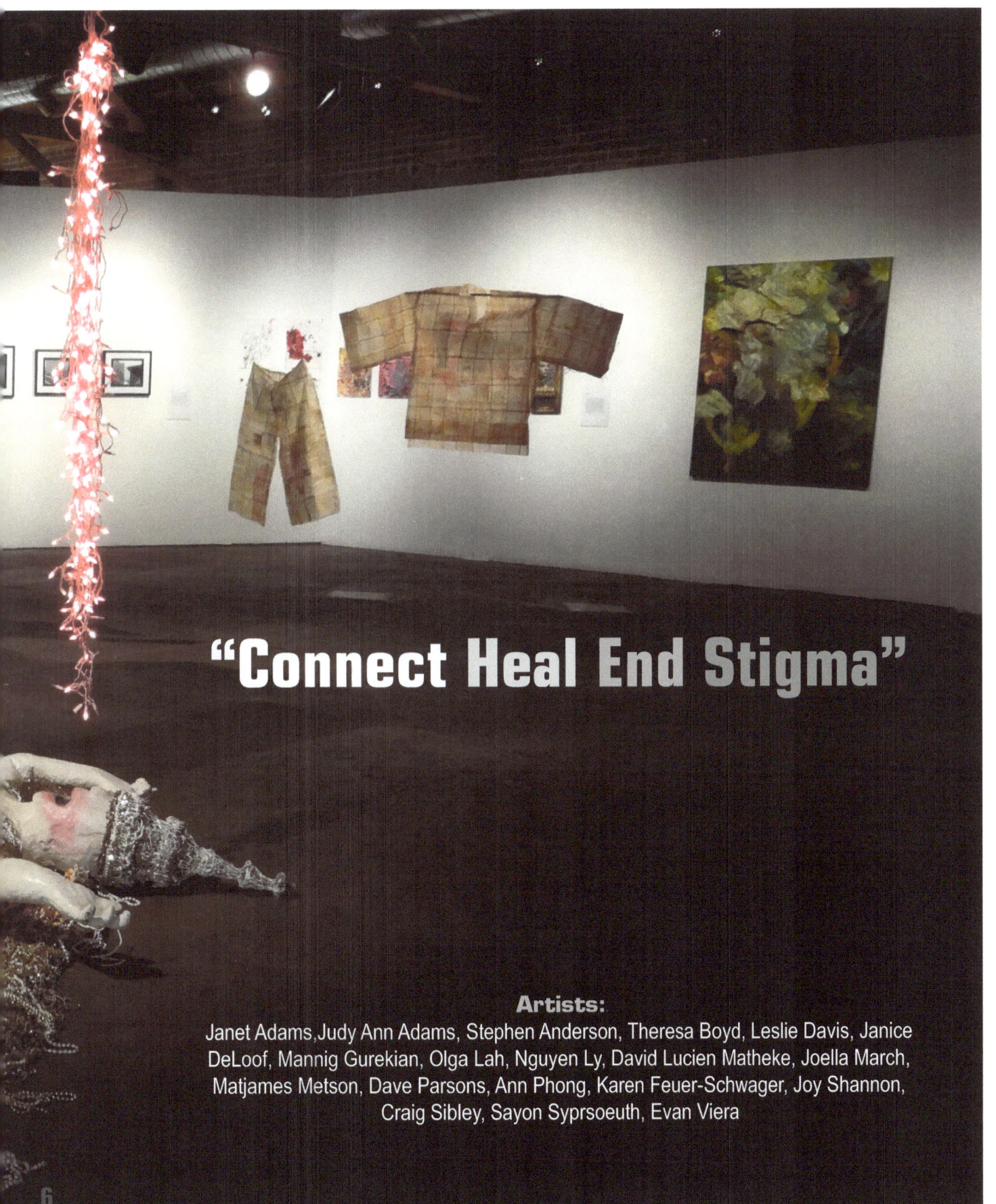

"Connect Heal End Stigma"

Artists:
Janet Adams, Judy Ann Adams, Stephen Anderson, Theresa Boyd, Leslie Davis, Janice DeLoof, Mannig Gurekian, Olga Lah, Nguyen Ly, David Lucien Matheke, Joella March, Matjames Metson, Dave Parsons, Ann Phong, Karen Feuer-Schwager, Joy Shannon, Craig Sibley, Sayon Syprsoeuth, Evan Viera

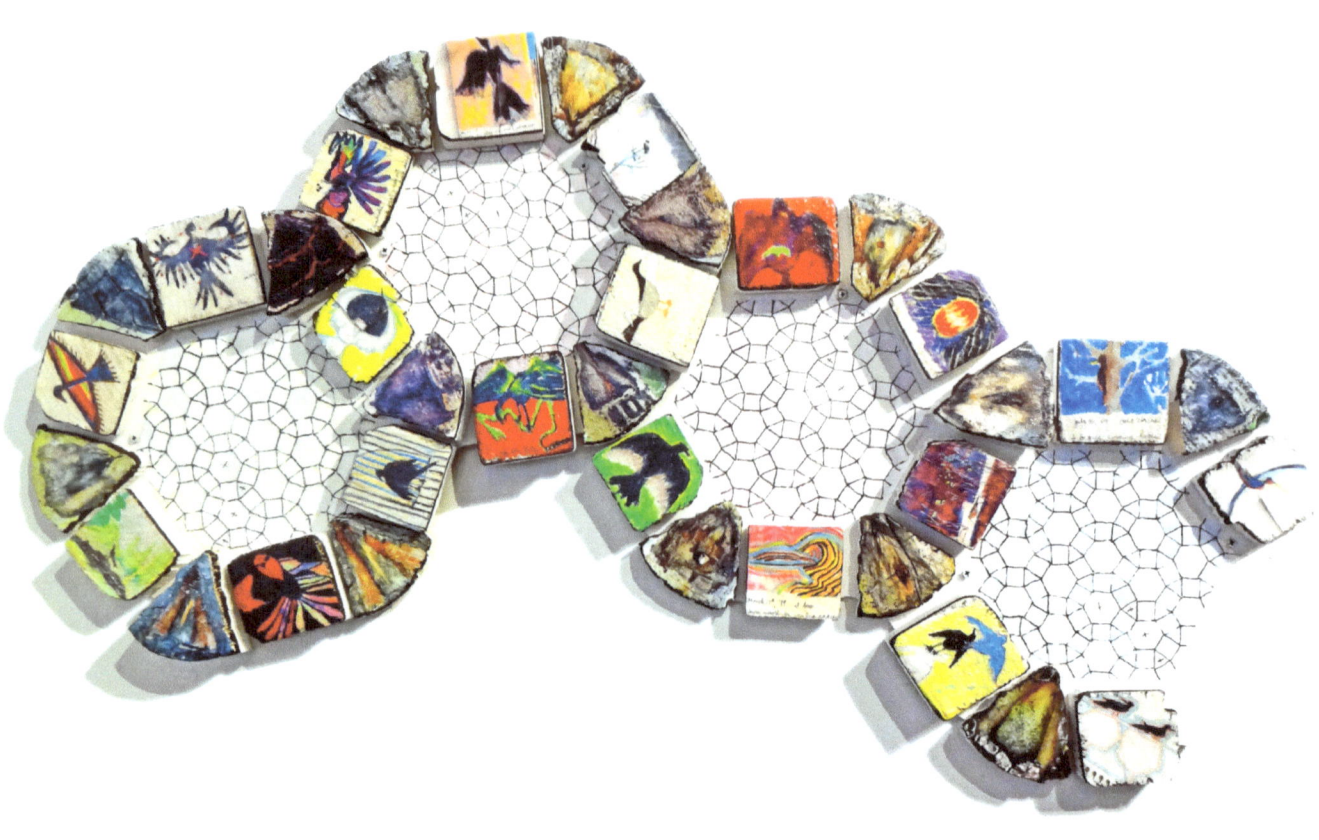

Janet Inez Adams

Forest Path
Mixed Media

Several thoughts - stigma for me translates stigmata - manifesting an outward sign of internal aberration.

Every woman artist of my era (pre Betty Friedan, Judy Chicago, Miriam Shapiro) existed in a male only art world. My art teachers (men) at Hunter College of The City University of New York would say - why do I waste my time on you, in 2 years you'll be married with 2 kids and never make art again. Yet they awarded me top grades and cash prizes... a real mixed message.

Well, I did get married and had 2 kids and my inner voice would say - now you have to get practical, produce something USEFUL TO SOCIETY. But I made art whenever/wherever - during the babies' naptime, at night, in the garden shed - and then stored it all under the bed. (a crazy time - labeled clinical depression).

I had no women artist friends until I went back to school CSUF for a MA - that's where I met Janice. And we realized that art was our lifeline to the transformation of the self into the universal self. That is when I studied Aesthetic Anthropology and the storytelling through art began.

With the piece "FOREST PATH" I visually am documenting the struggle and joy of the above. When Janice asked me to be part of the OCCCA show and teach the AIR, she asked for a piece specific to the CONNECT END STIGMA theme. I started the piece last August and completed it this June.

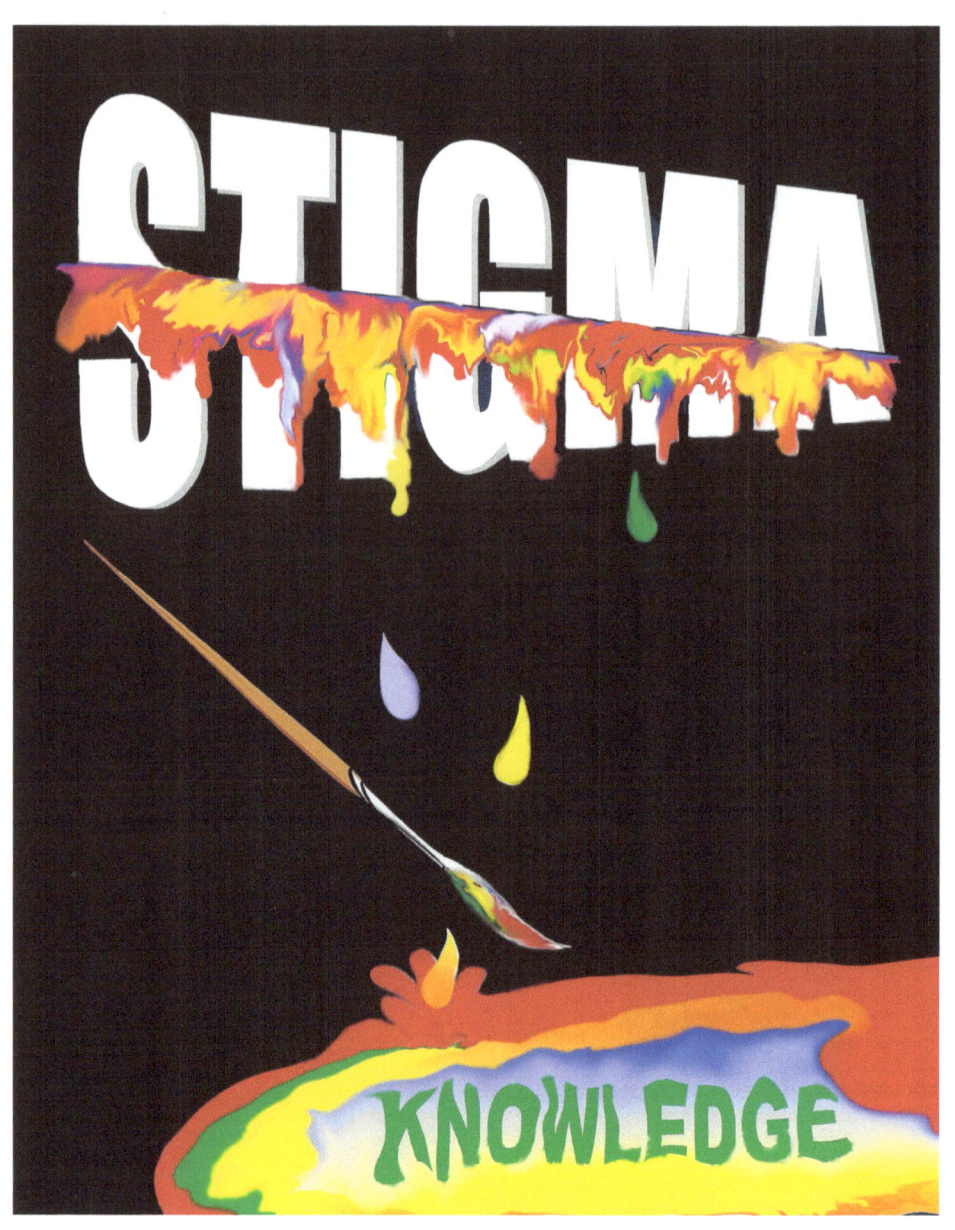

Judy Ann Adams

Stigma – Knowledge
Mixed Media

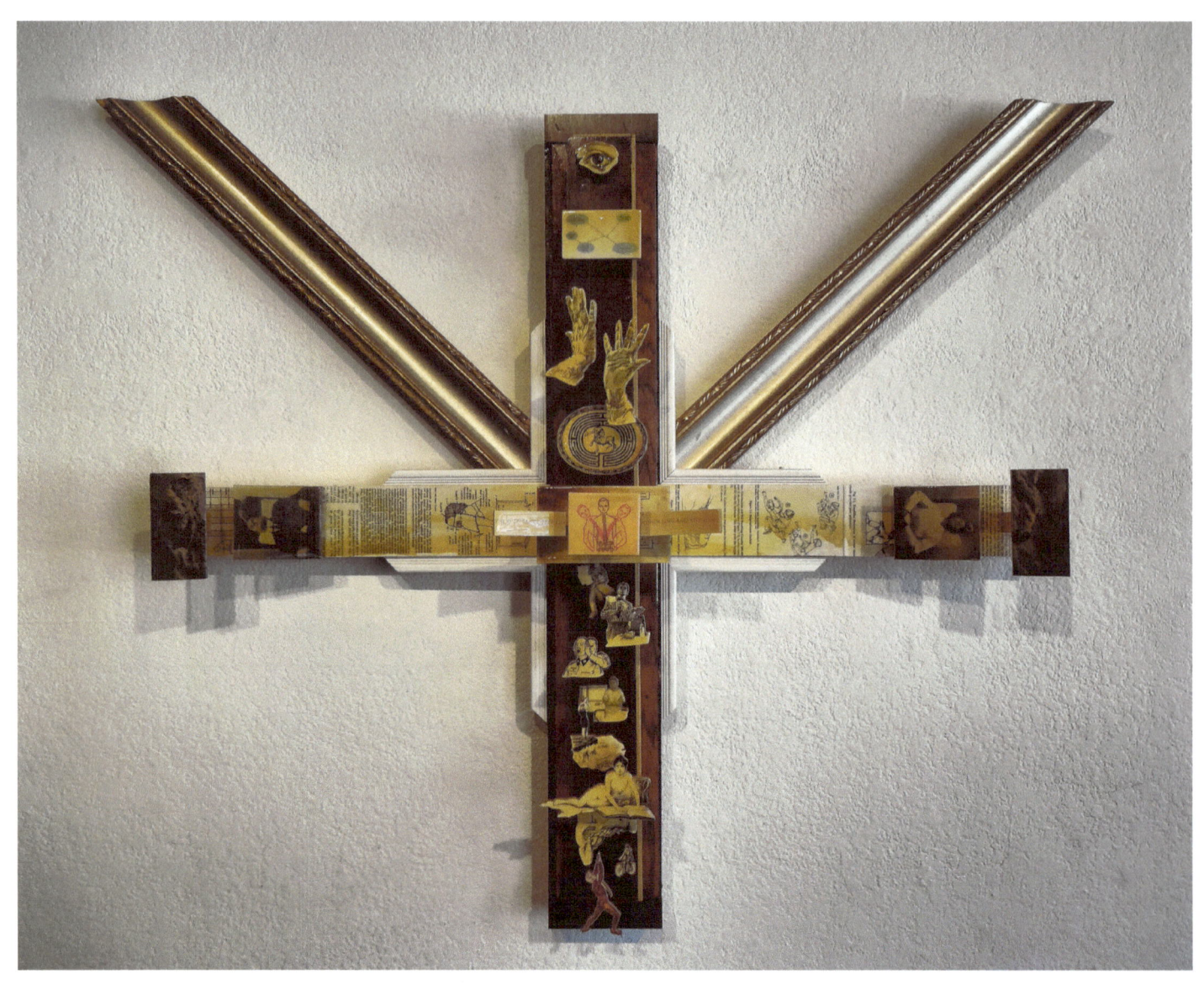

Stephen Anderson

The Difference Between Knowing and Wondering
'Pop-up' collage on hand cut wood, picture frames,
plastic, polyurethane on found and new wood
41" x 50" x 7¾"
2013

There is a thin line between 'knowing and wondering' if one has a mental illness.

Statistics show that on average a person lives (or deals) with an illness undiagnosed for 10 years. A major factor in not getting a diagnosis is the stigma attached to mental illness, people simply do not seek out help for fear of being labeled 'crazy' by others and by themselves.

> The US Surgeon General stated in 1999 that: "Powerful and pervasive, stigma prevents people from acknowledging their own mental health problems, much less disclosing them to others."*

Stigma was a major factor for myself and why I fell into the statistic of not getting help. It took encouragement from a friend who also went through similar depression and anxiety to seek help.

One does not want to be a statistic or labeled so before seeking help art was a major factor in dealing with my internal battles. Art provides a way of cathartic purging by confronting dark areas of ones brain and letting it out in a creative physical way. It became for me a personal visual diary, as seen in my prior series; 'Burned Fingers series of 1,000' composed of small collaged paintings that the viewer could pinpoint how I felt on any given day.

The current 'Pop-up' collages, which are in this show, although are personal, are also more of a general observation of the world at large. Sarcastically pointing out the mundane, and societies ills, with a hope of evolving beyond what we currently understand life to be.

The imagery is all found materials often from old science books, mounted on wood and meticulously cut with a scroll saw. The piece starts with finding a slogan from advertising and deconstructing it from its purposes of selling to something more profound.

*"A Vision for the Future". Mental Health: A Report of the Surgeon General.
National Institute of Mental Health. 2009. pp. 451–8. ISBN 978-0-16-050300-9.

Theresa Boyd

God is Here
Film Photography

During 1991-1992 I volunteered at The Lighthouse Homeless Drop-in Center in Santa Ana. It was my first experience working with people who had lost everything probably due in great part to their mental illness. Everyone had a story.

The photos I took portray a bleak setting, dark, dirty and surrounded by barbed wire. At the time it was one of the only places of its kind.

Because of my deep desire to change the standard of mental health care, I joined The Orange County Mental Health Board. Our duty was to report to the OC Board of Supervisors on mental health services. Through this affiliation I met many people and became a public speaker advocating for housing for people with mental illness.

The most gratifying experience was speaking at The Anaheim City Council meeting, filled to capacity , advocating for a project designed by Jamboree Housing and H.O.M.E.S. Inc. The neighbors came out to denounce the apartment building because they feared "the mentally ill." A 9-year-old spoke about being afraid to walk her dog because a mentally ill person might hurt her! The City Council saw through the fear, stigma and "NIMBY" (not in my backyard) attitudes and passed the measure in defiance.

The first step to treating mental illness is providing a stable home.
Now the Diamond Apartments is built and its beauty improves the neighborhood!!!

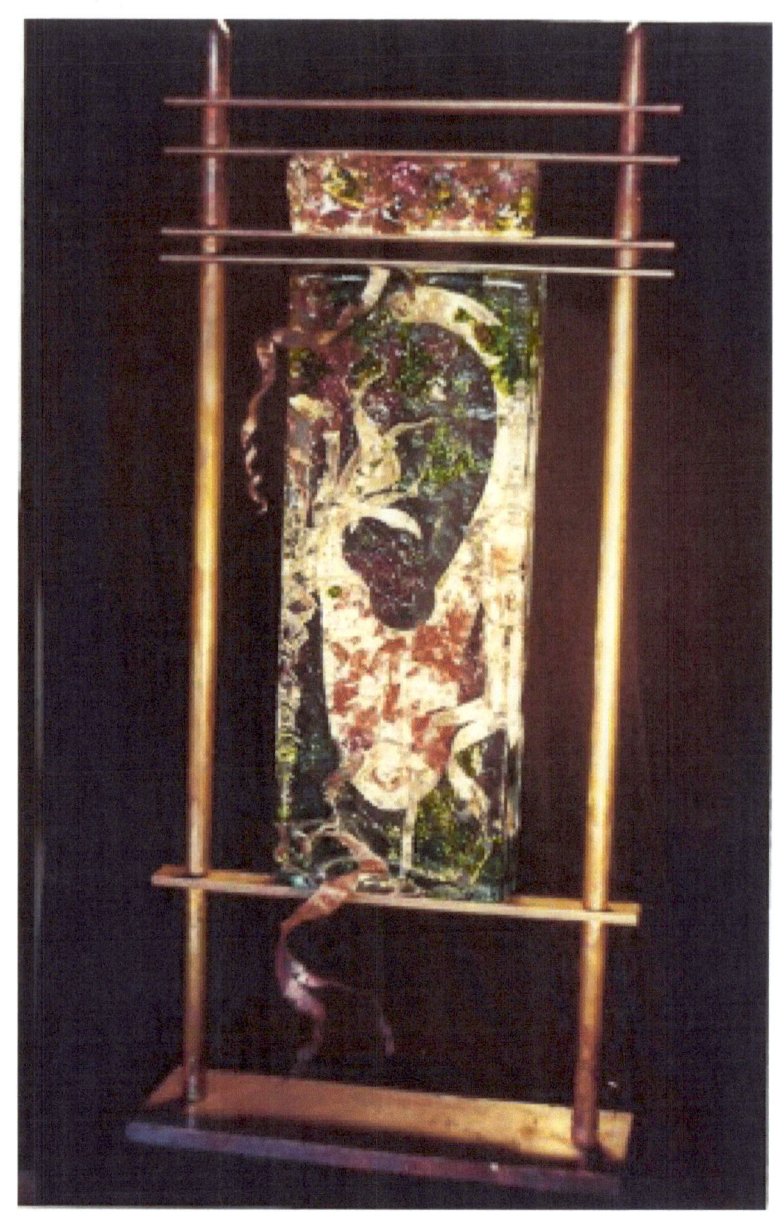

Leslie Davis

The Frozen Woman
Furnace cast glass with copper mask inclusion
28" H x 12" W x 2" D

The frozen woman was created at Pilchuck Glass school, while I was working my way through a deep and pervasive depression. I was unable to move forward with my life or look backward. I felt literally frozen in time with no hope for a positive outcome.

This piece gave me a way to communicate and release what I was feeling. Using my art as a way to break through debilitating depression has been a part of my life since my early teen years. I come from a family of clinically depressed people who now have positive and productive lives due to effective medical and psychological therapies and they are all successful working artists.

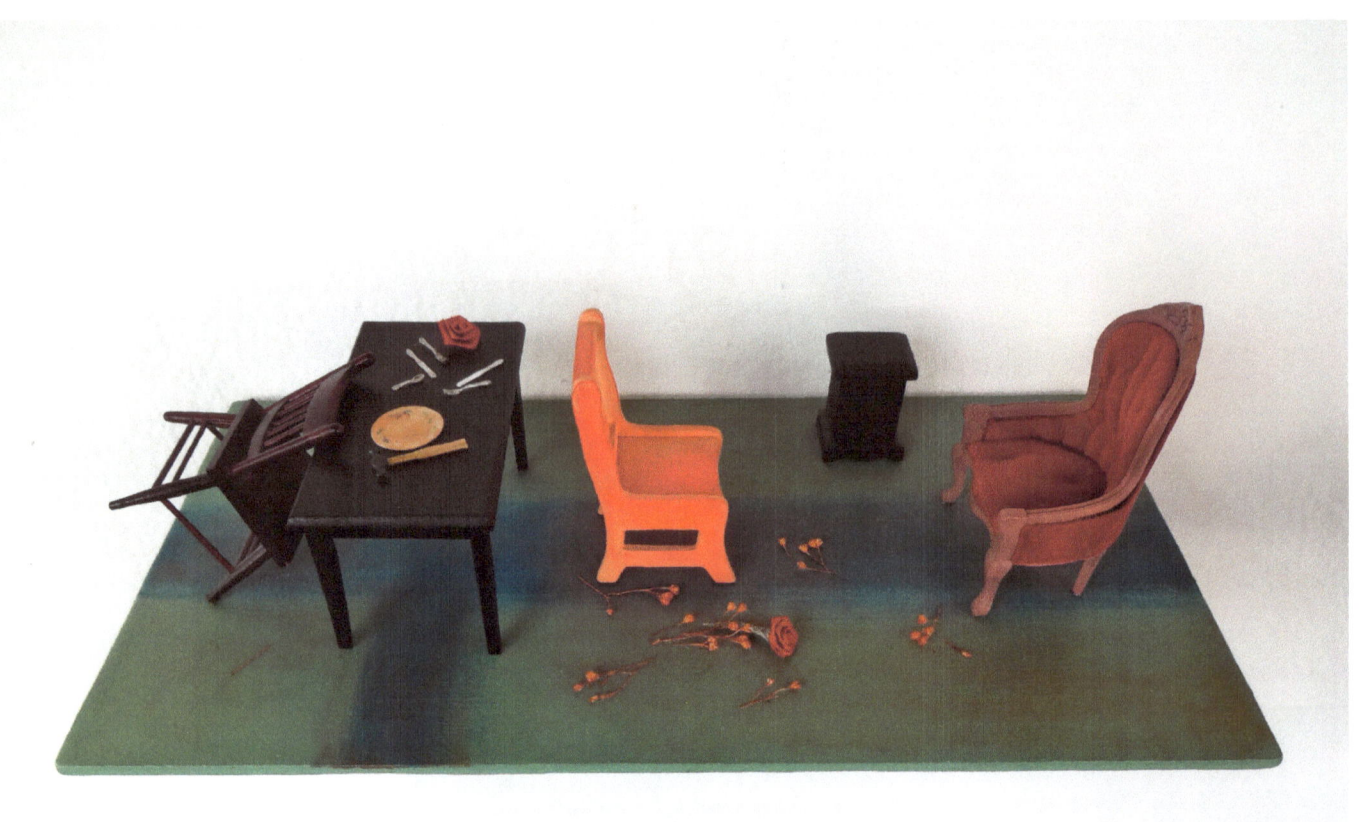

Janice DeLoof

Confrontation
Maquette

1938-2013

BIOGRAPHY

Artist, teacher, and mental health advocate Janice DeLoof died in March of this year. She was the driving force behind this ARTS END STIGMA festival from its genesis in 2010 until her death. A graduate of Cal State Fullerton, she is best known for her colorful tableau images, miniature sculptures and participatory installations that use domestic furnishings to suggest emotionally charged narratives about family upheaval and failures to communicate. With two mentally ill sons, she was highly motivated to use art to heal from personal trauma. For years she curated art exhibitions, led workshops, and organized panel discussions on the role of art in healing or reducing the stigma of mental illness. She also chaired the Government Affairs Committee of the local National Alliance on Mental Illness (NAMI) and effectively advocated at the county and state levels for improved treatment of the mentally ill.

STATEMENT

"Recurring images of furniture and various utilitarian objects are symbols and signs from my own personal vocabulary of memories used to create visual narratives on wood, canvas, or embossed paper. I see art as a means of bringing people out of isolation.

The art begins the conversation about feelings and relationships, and the mind of the viewer completes it. Conversation, both private and public is an exchange – an attempt by the individual to integrate or reconcile with others in the community. To converse is to identify one's self in relation to another person or idea. Art becomes a tool of investigating the structures of social interaction."

Janice, December, 2012

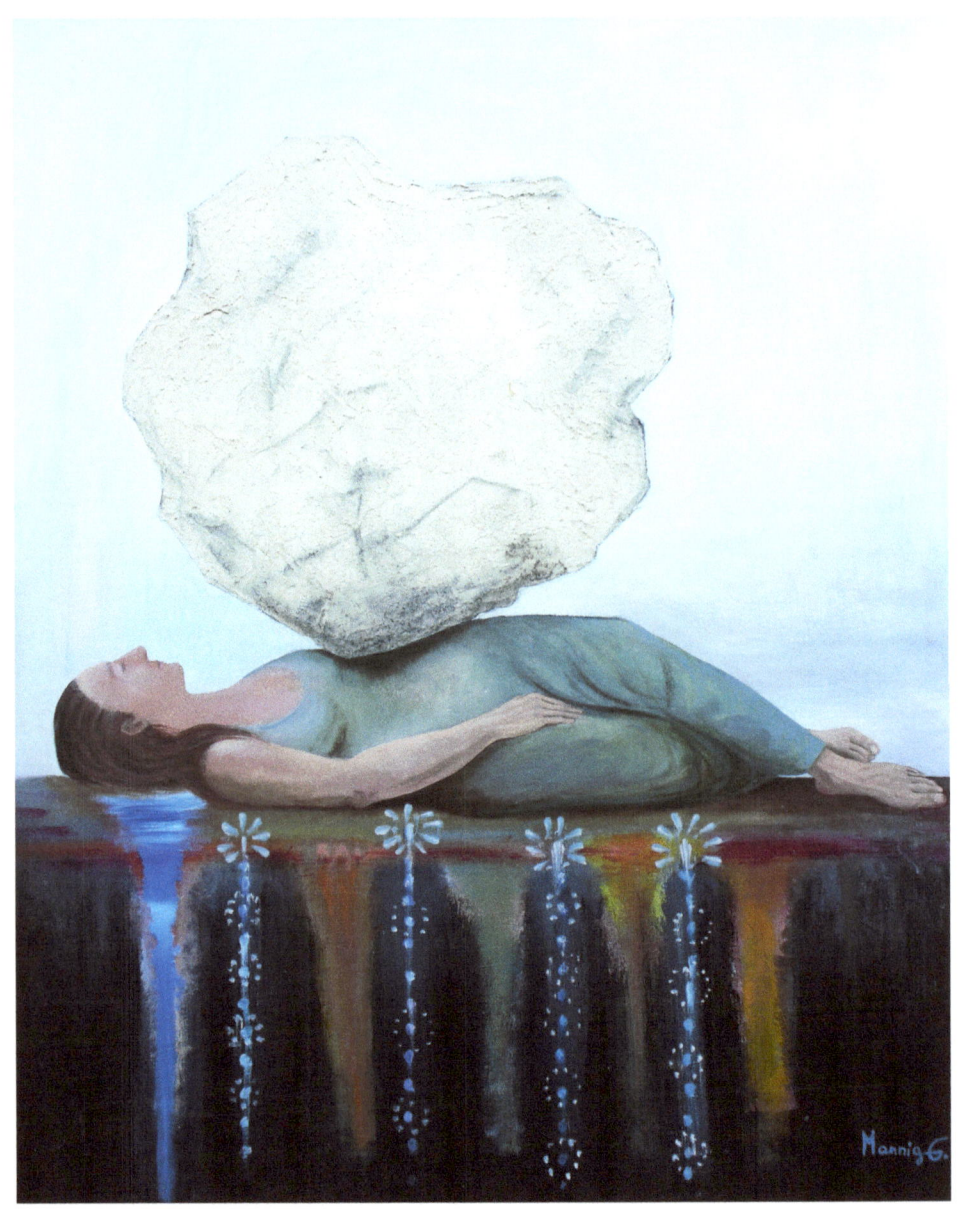

Mannig Gurekian

The Release
Acrylic Painting

STATEMENT

The burden of living with depression (or living with someone that has any mental health issue) seems at times too much to bear.

From my experience, this weight can sometimes lead to a state of paralyzed loneliness. Being part of an informed and understanding community makes a big difference, it helps to release the weight, so it becomes lighter and more manageable.

BIOGRAPHY

I am an artist, arts educator and co-founder of "The Art of Daybreak Multi-Arts Outreach Program" (established in 1996), which brings hands-on arts workshops to persons with mental illness who are served at Mental Health Centers, Wellness Centers and Homeless Shelters throughout Los Angeles and surrounding Counties.

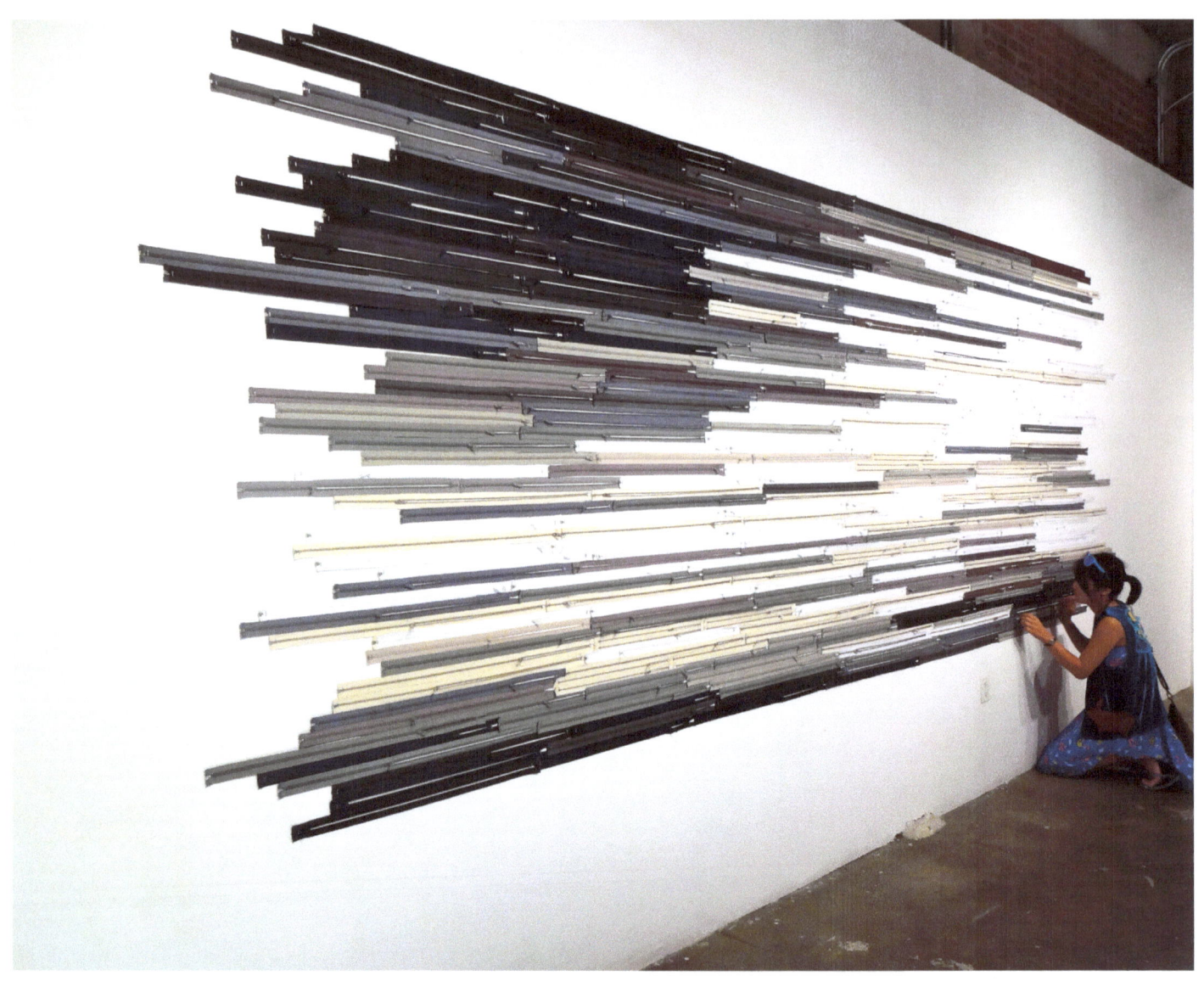

Olga Lah

Confession Session
Interactive Installation, zippers

Confession Session is created out of almost 350 discarded zippers. This site-specific installation invites viewers to interact with the piece by writing confessions directly on the wall behind a zipper. In relation to this exhibit, confessors are asked to write their most personal feelings or thoughts on mental health issues.

Confession Session is about disclosure and discovery. It is as much about releasing ideas in the security of anonymity as it is about uncovering thoughts that are affirming, questioning or surprising. It points to a greater empathy as we become increasingly open to reflections on mental health.

How do you feel/think about mental health? Unzip and confess! Feel free to write your confession within an open zipper, then zip it up if you desire!

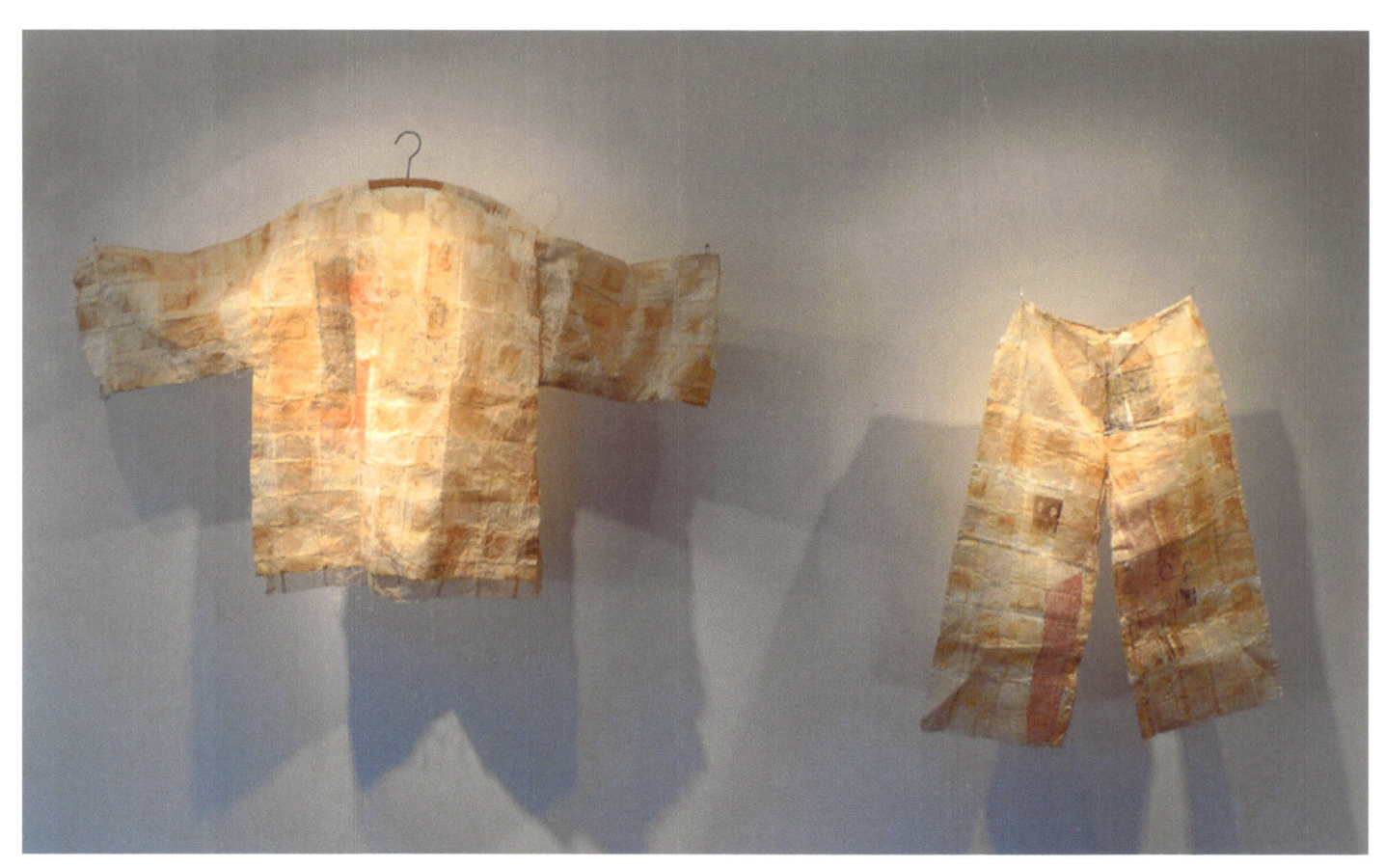

Nguyen Ly

Untitled 2 and Untitled 3
Recycled paper tea bags, thread, paper lithography
2012

These works are about the memories of my childhood in Vietnam. They are ephemeral and incomplete as are the images I make. The images are of my family and ancestors, of old clothing and threads and of roots and beetles' wings. Making these works is a way of connecting with those memories of which at times seem like a lifetime away. When talking about my work, a friend James Dinh, once observed that the clothing pieces "seems to be about the "skin" of personal/family history that we literally wear around with us and which informs who we are, while being both an uneraseable marking and a protective covering at the same time."

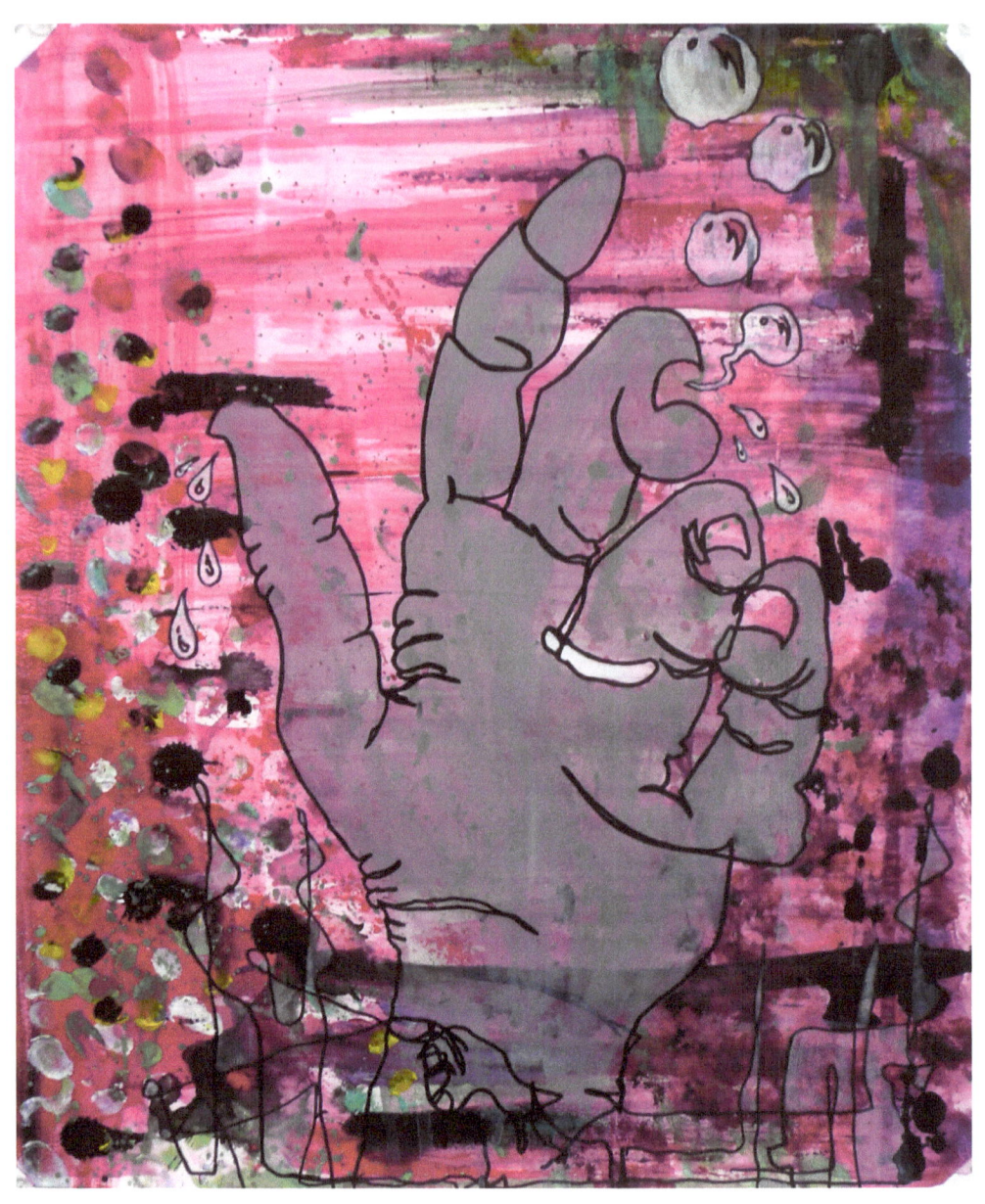

David Lucien Matheke

Ghosts of the Passed
Mixed media on paper

I am an extremely confrontational artist. My work is about disease, recovery, life and death, empathy and my voyage of learning to live in my own body.

When I was three years old, I was diagnosed with an extremely rare immune deficiency disease called Bruton's Type X-Linked Agammaglobulinemia. I require monthly infusions of medication made from plasma extract from thousands of donors. Growing up, this was incredibly difficult to cope with and caused me to suffer from severe depression and anxiety. These negative feelings affected every aspect of my life; causing me to lash out at those I love and constantly doubt myself. I questioned whether or not I could even have an identity given that my blood, my life force, consisted of my dysfunctional blood and that of thousands of faceless donors. I eventually fell into substance abuse and drug addiction as a coping mechanism during my teenage and young adult years.

Never knowing whose life energy is inside of me from one month to the next is still a major contributor to my anxious nature, but I choose to confront it with my art making process. The blind contour drawings are a metaphor for the anonymity of these donors' presence inside of me. Exploring these darker thoughts and ultimately confronting them is an immense release; they no longer consume and control me. Artmaking has helped me to manage the depression that has haunted me throughout my life and has given me a means to cope with my high levels of anxiety.

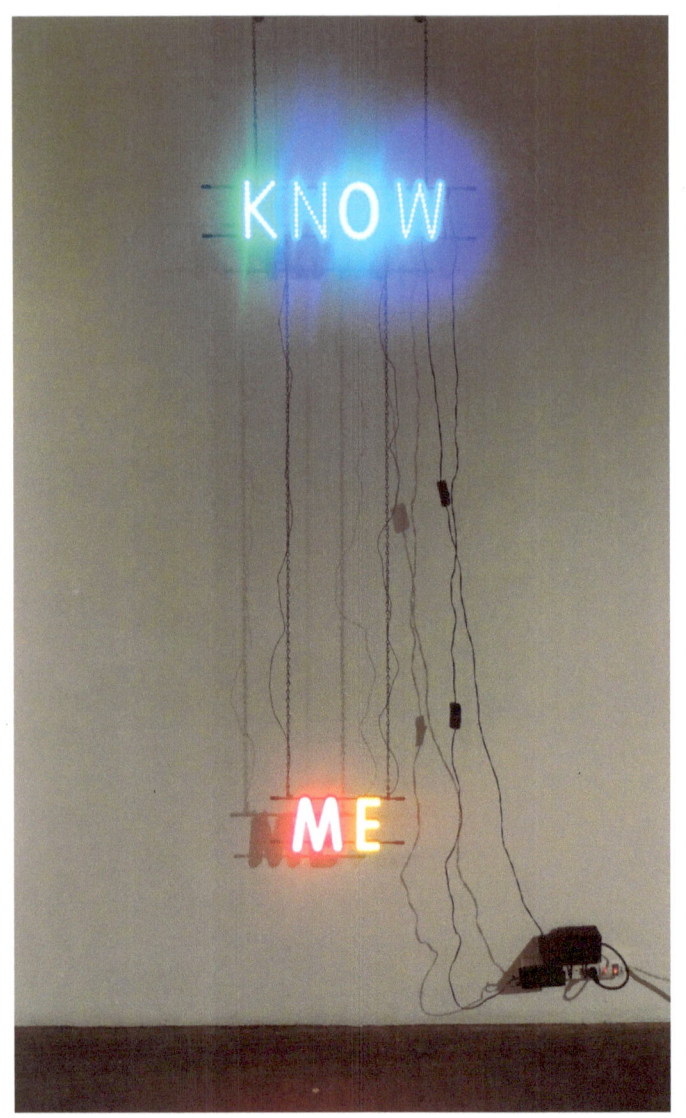
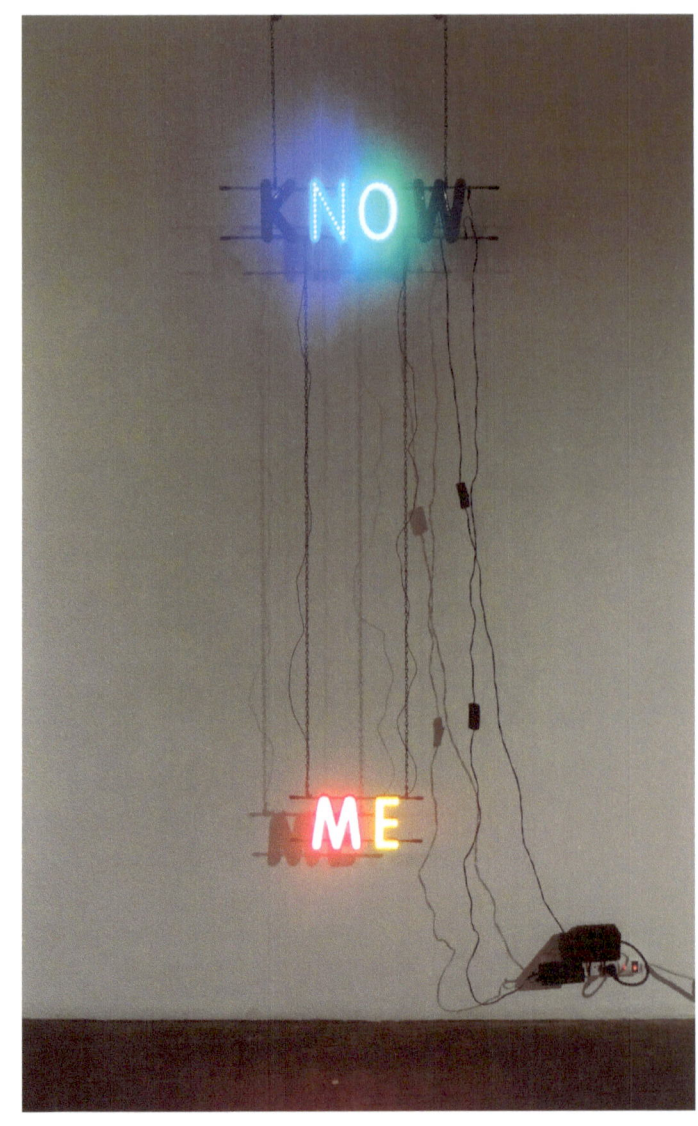

Joella March

To Know
Animated Light-Based Text
L.E.D.'s , armature, electronics
2013

STATEMENT

I grew up in a time when ignorance and stigma was rampant. Public education and resources about mental illness were slim and stilted. It was at this time that my older brother's illness of Schizophrenia emerged and soon became the family secret. As a child I remember feeling isolation, shame, and confusion as I wondered: "why was this a secret" and "why should we feel ashamed, less than and silent about an illness that no one had invited into our family"... "What had my brother done wrong?" He had done nothing wrong yet my family, feeling they had no other choice, had fallen victim to a paradigm of stigma and shame by remaining hidden and silent.

Several years later my mother fortunately discovered friends and other families who were struggling with similar challenges and she soon became one of the founding members of the National Alliance on Mental Illness (NAMI), and the California Alliance on Mental Illness (CAMI). These organizations offered the support, resources and education that our family and others so desperately needed to guide them and their family members towards the best possible care and recovery. To this day my mother is a vocal member of NAMI and an on-going active community advocate for mental health awareness – wellness, recovery and - health care legislation.

This artwork is informed by the messages about stigma that I had received as a child: Mental illness was to be kept invisible, it was shameful, and no one could ever know~find out the secret truth about our family. Messages of self-negation, to remain silent and remain unknown are reflected in the sub-text. This work also embraces another message, (in the core text), one of hope, courage, empowerment and self-acceptance, an invitation to challenge the stigma of mental illness and "be known", without shame or pretense.

BIOGRAPHY

I am an artist, exhibition curator, arts educator and co-founder / director of "The Art of Daybreak Multi-Arts Outreach Program" (established in 1996), which brings hands-on arts workshops in fine art, creative writing, improv, music and dance to persons with mental illness who are served at Mental Health Centers, Wellness Centers and Homeless Shelters throughout Los Angeles and surrounding Counties. "The Art of Daybreak Multi-Arts Outreach Program" seeks to enrich lives, eliminate stigma, and encourage hope and goals, while increasing wellness and recovery, through hands on involvement and exposure to all the arts.

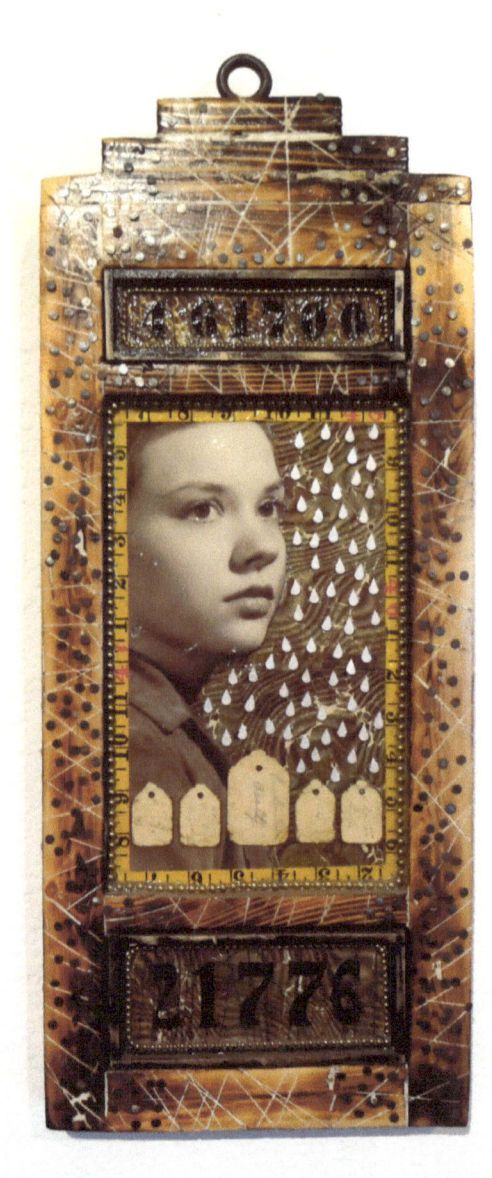

Matjames Metson

Prudential Realty 21776
Mixed media
2012

I try and push myself. I work as hard as I can every day. The medium, the subject matter and the materials demand it. I work directly with time, memory, and ghosts. What I am doing is translating voices that are not being heard. Building homes for vanished things needing a place to settle. Creating safe areas designed to respect what may seem like such common items, yet items which hold an alarming resonance – a haunting if you will. I grew up in such a nomadic way, yet always returned to Charlotteville, a small village in Schoharie County in Upstate New York, between the Catskills and Adirondack Mountains. It was an abandoned place but rescued from oblivion and loved and maintained by a small resident population. Later, the allure of New Orleans pulled me into her web and there I stayed for nearly two decades, honing my craft in an antebellum atmosphere. Hurricane Katrina changed that. Katrina brought me to Los Angeles and challenged me to rebuild myself and my artwork. The voice became louder but slower. The style of my work went from bold, strong and rugged, to far more elegant, refined, and with painstaking complexity. Going from having all the materials I needed to having none taught me a whole new craftsmanship that set my work apart – even from my own past accomplishments.

I strive not toward perfection but for complexity and challenge. I want to challenge not just myself, but the viewer. Having little formal academic education and zero formal art school, I chase geometry and math. I want the sculptures I build to echo architecture…cathedrals and monuments. The pursuit is for craftsmanship as well as fine visual art. The idea is to combine many aspects, not as "multi-media" but as multifaceted skill sets. My goal is to create sculpture that uses architecture, geometry and craftsmanship in balance with fine art.

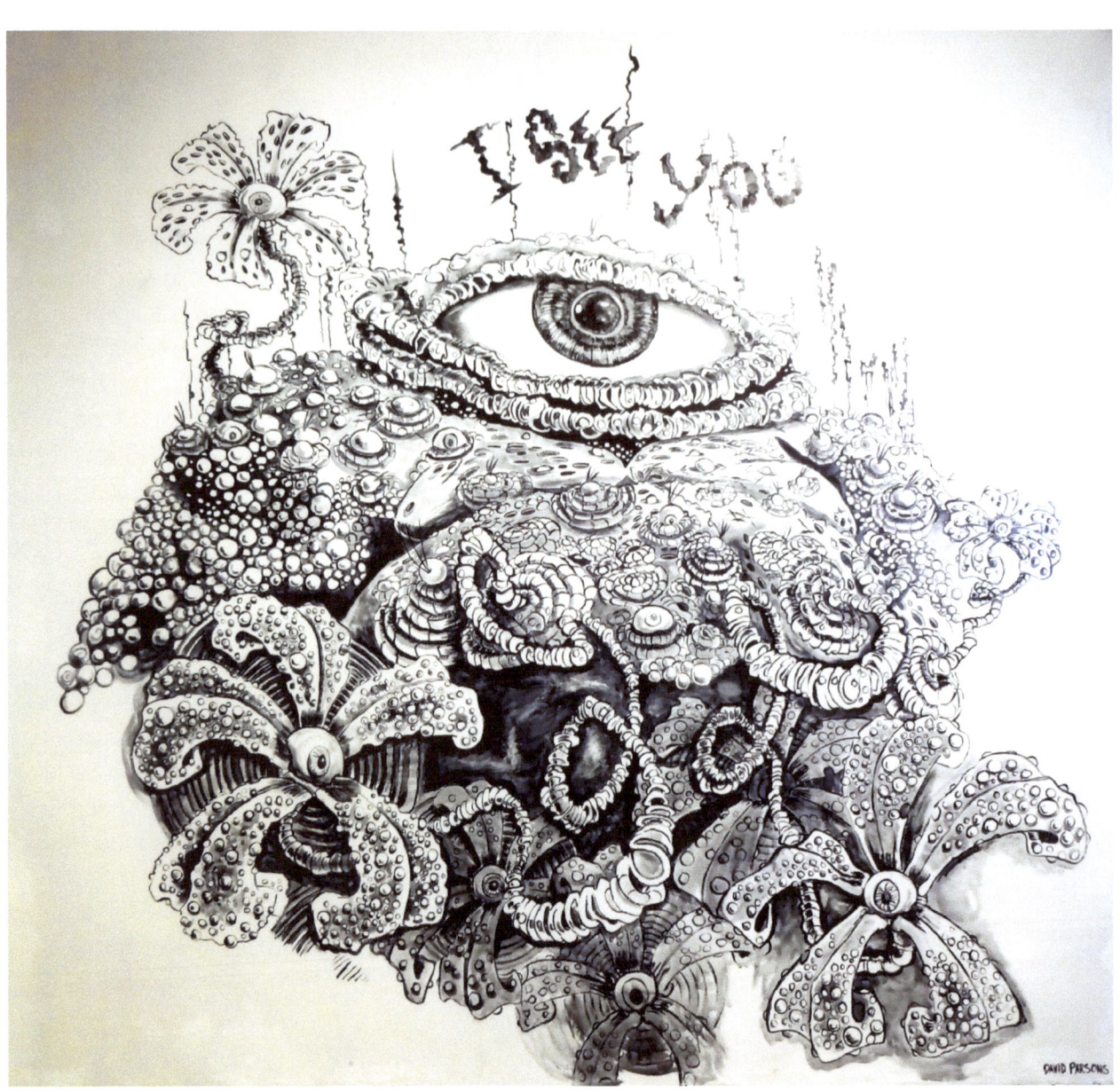

Dave Parsons

I See You
Wall Mural
2013

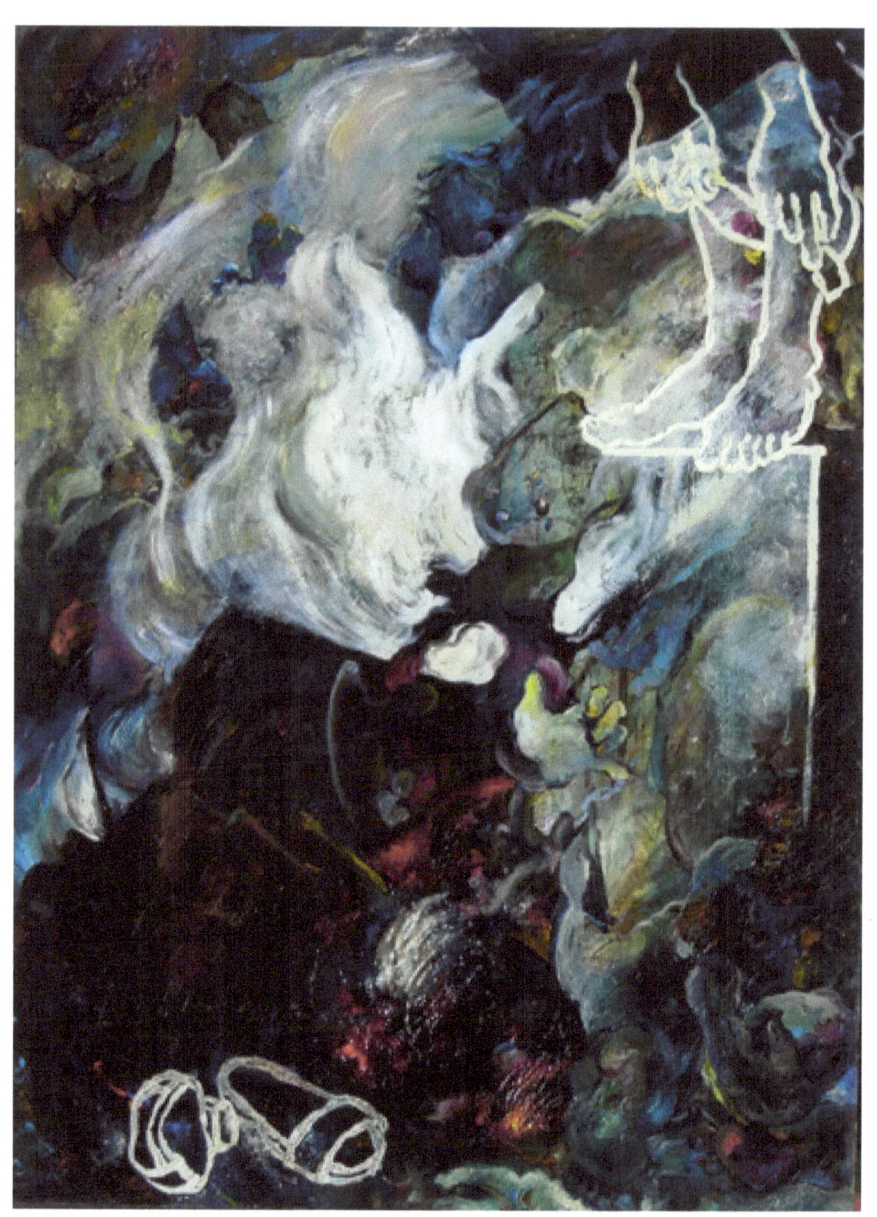

Ann Phong

Jump
Oil on canvas
84" x 60"

Ann Phong was born in Saigon, Vietnam. In 1981, she had a chance to escape Vietnam by boat and has since settled down in Southern California.

In 1995, Ann received her Master of Fine Art degree from California State University, Fullerton and has actively participated in more than 70 solo and group shows in galleries and museums. Her work has been widely exhibited in Los Angeles, Orange County, San Francisco, Houston, Vancouver, Paris, Thailand, and as far as Japan.

Ann's paintings have been collected by the Queen Gallery in Bangkok, the Cal State University Fullerton Student Center, the BSC at Cal Poly Pomona University, as well as various private collections. Some of her works are included in American high school text books, such as Literature and the Language Arts, published by the EMC Corporation.

Ann Phong currently teaches art at Cal Poly Pomona University. She has also been invited to speak by many high schools, colleges, universities, galleries and museums on the subject of her own work and work of other Vietnamese American artists.

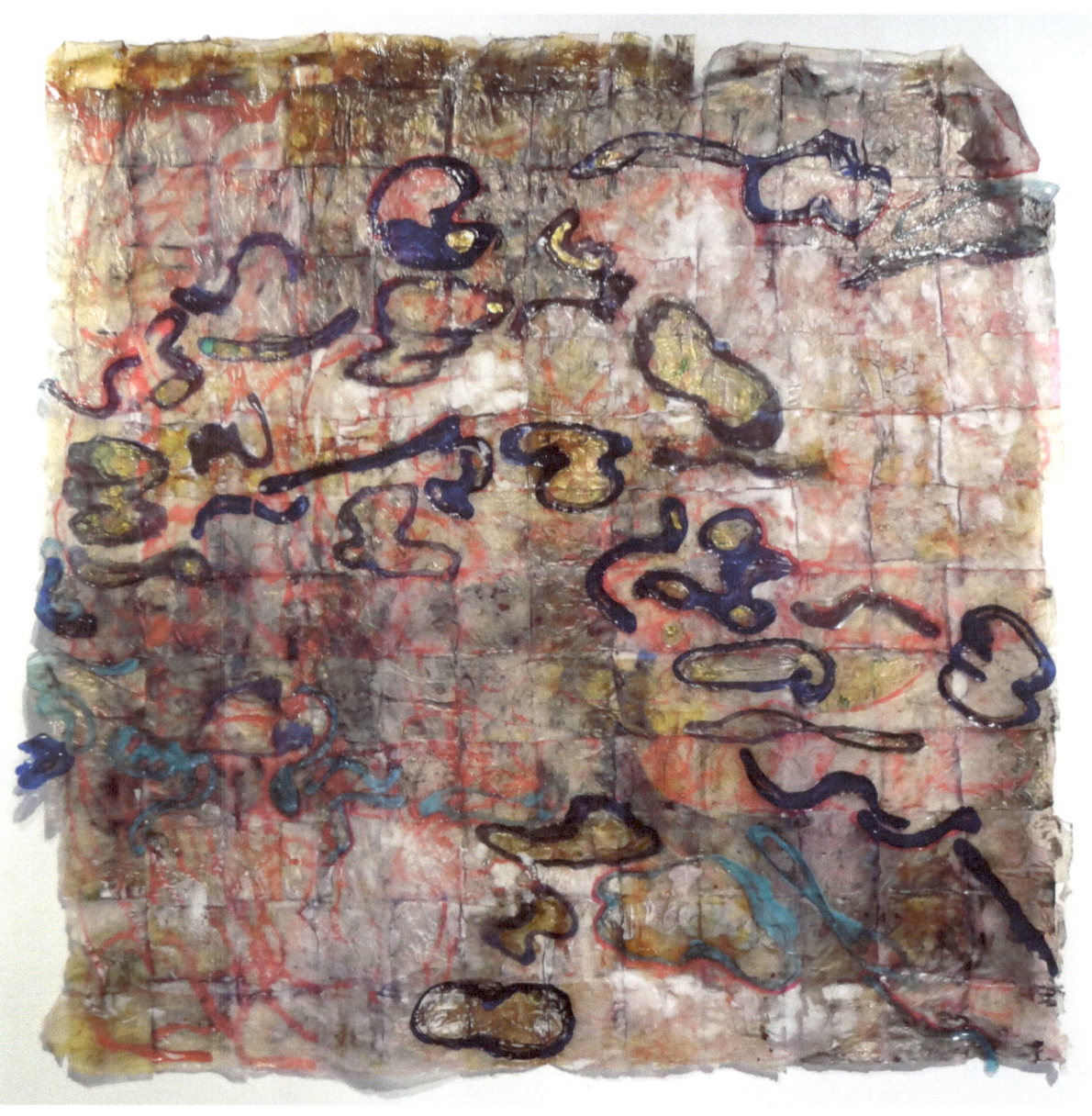

Karen Feuer-Schwager

Tikkun Olam series: Shattered
Acrylic and polymer skins on canvas
36" x 36"

The objective of this project is to conceptualize what I call ones "mental garments," offering a way of seeing, in addition to fashion trends, ones persona's draped outer public presentation (tossing, in essence self-images on a hook to investigate).

These funky baroque wraps and twisted drapings are constructed using bits of ordinary materials which would normally discarded be tossed in the trash without much thought. These surprisingly sensual and ephemeral materials, such as tea bag silk, tea bag strings and recycled beads, combined with binders and polymer skins, have intriguing alternative uses. Out of these materials I have fabricate quasi fabrics into sculptural garments which appear to be almost wearable.

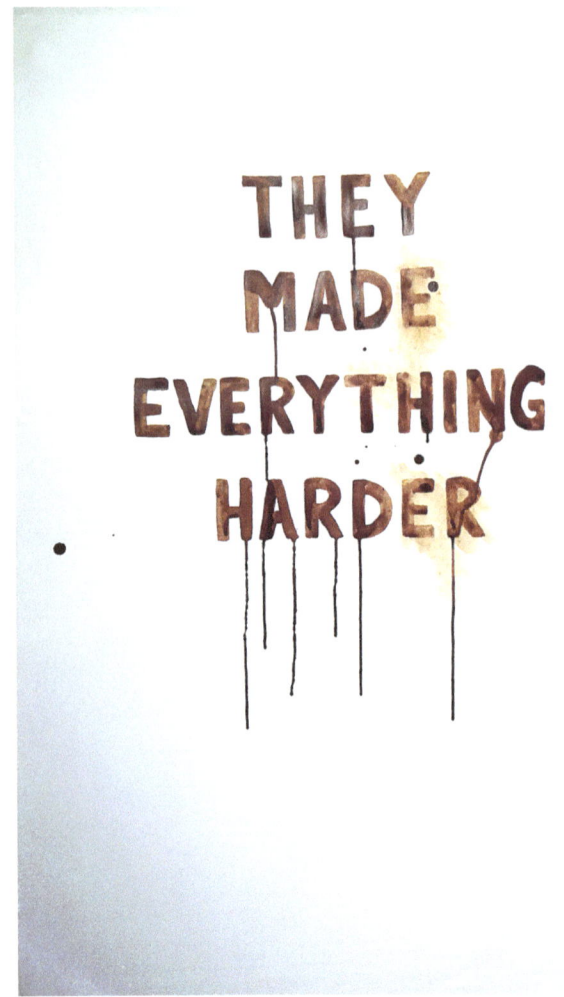 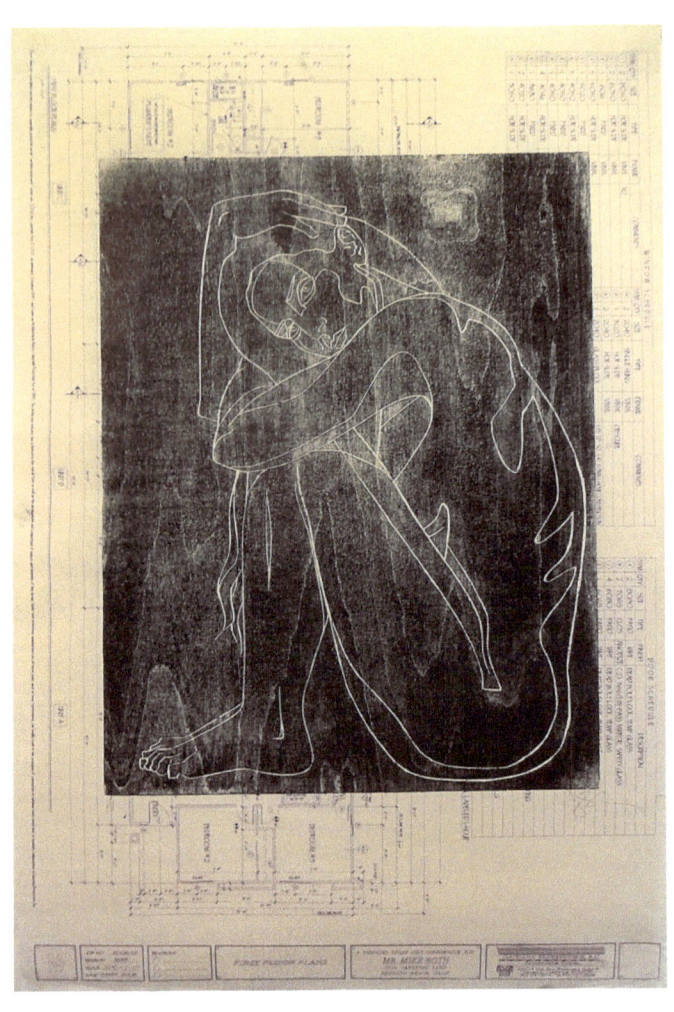

Joy Shannon

They Made Everything Harder
Mixed media on cotton-based paper
2012

Woman Contained #1
Woodcut on blueprint
2010

STATEMENT

This particular series of prints confronts the process of healing from abuse, and Post Traumatic Stress Disorder (PTSD), which can feel like not only a process of healing the mind but also healing the muscle memories of the body itself. I have utilized the imagery of blueprints to represent the idea of our bodies as our homes and how abuse can make that home feel "broken into" and violated. Additionally, the process of healing can feel like rebuilding trust into one's mind and body again. I also accompany some of my pieces with quotes about healing and the confronting of perpetrators, written in menstrual blood. The use of this medium is inspired by the idea of "de-shaming" the female body while speaking the truth about abuse.

BIOGRAPHY

I am a recording, performing and visual artist front-woman of the band "Joy Shannon and the Beauty Marks." I have a bachelor's degree in Theatre Arts and Visual Arts and a Master's degree in American Studies with a focus on cultural art history from California State University at Fullerton. My art and music are deeply inspired by cultural history and express my emotional reaction to historical issues, especially women's issues. I create printmaking and mixed media works on paper which use the figure to express human emotions and spiritual concepts.

Craig Sibley

When Despair and Fear Grip my Heart
Digital print

About 5 years ago, I lost my job in the corporate world. I was a very successful public speaker and music/recording technology guru. I found myself in my mid-fifties, no longer wanted or needed in the industry I had helped develop. It appeared I no longer had "the look" and also, was at the top of my pay scale. A younger, thinner, faster albeit less experienced "me" could be hired for half the money I'd been making. I felt my life was over. It's strange and tragic how much of "who we are" is deeply attached to "what we do".

I fell into an extremely deep, dark depression. Thoughts of suicide raced through my brain on more than one occasion.

This art piece is how I felt inside. My heart was dark and empty, with a red-hot shard of metal piercing through it.

My sweet, lovely wife was the only thing keeping me going. At some point, she suggested I do something fun, such as taking a watercolor class at a local college. I felt this was something unthinkable. First of all, I didn't want to be surrounded by uber-talented young kids who'd make me feel worse than I already was. The second reason is that as a kid, I'd wanted more than anything to be an artist. Unfortunately, my father forbade it. He told me I'd never amount to anything other than a ditch-digger if I were to pursue this path. So upon his insistence I found a career in the corporate world instead, worked like a dog, made lots of money, and was absolutely stressed, unfulfilled and miserable.

After a few months, I relented and took that Watercolor class my wife suggested. To my surprise, it came very naturally and easy for me. After a while, the kids around me started asking me questions as if I was some kind of "authority". My instructor was so impressed with my first painting; he entered me in a "Best of Southern California Collegiate Artists Show". I won "Best of Show" at that exhibition. No one was more surprised by this than me.

Now, I often struggle with bouts of depression however it is more fleeting, and less severe. Somehow art redeems me, pulling me out of a full nose-dive. I'm now a professional artist, making very little money… but I'm happier than I've ever been in my life. I thank God often for two things; my understanding and loving wife… and the fact that life is now exciting, new and fresh.

I believe art literally saved my life.

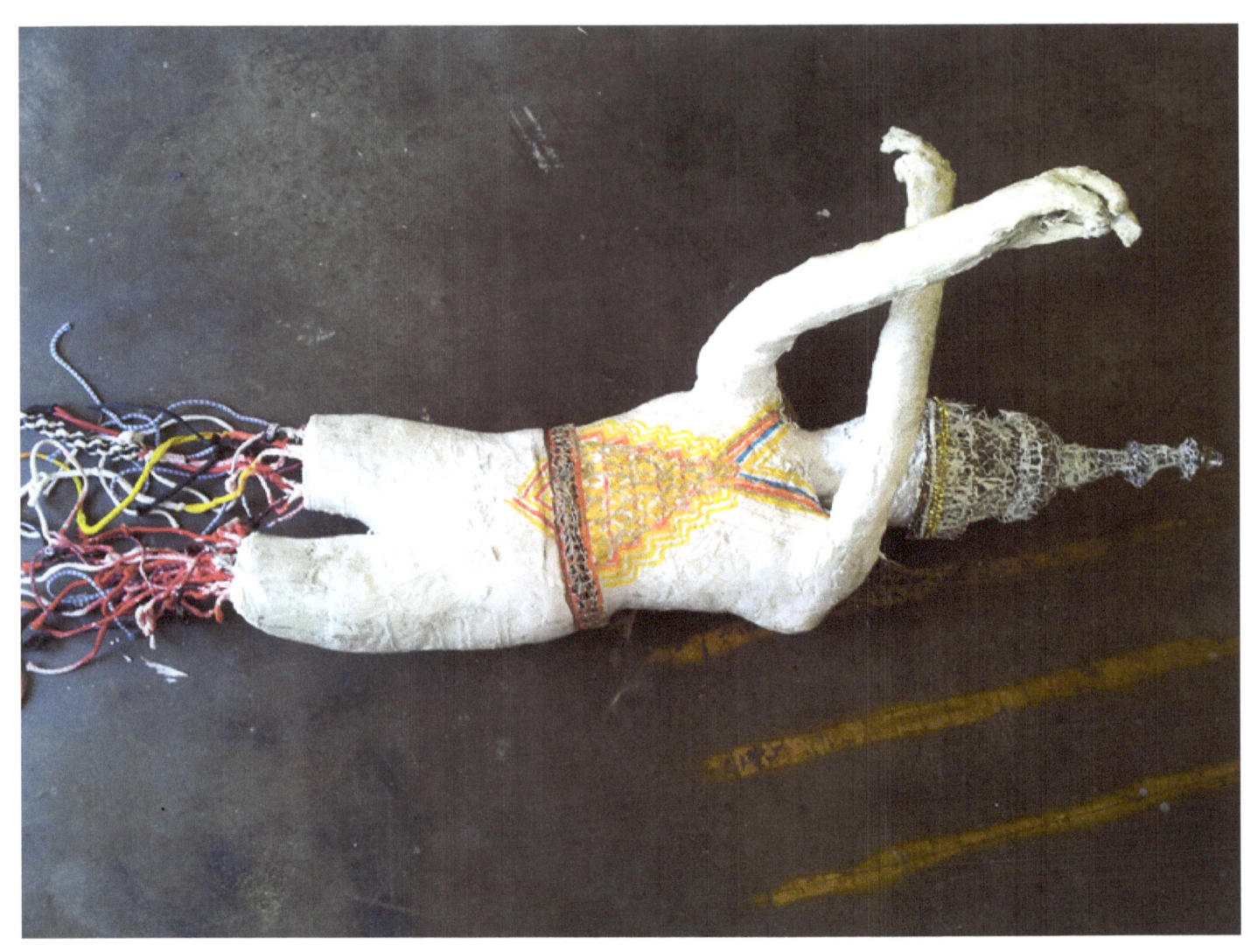

Sayon Syprsoeuth

Falling Down
Mixed Media
2011

Sayon Syprasoeuth is a Laotion/Cambodian/American artist who escaped the Khmer Rouge into Thailand's refugee camps with his family as a young child.

His various media (sculpture, installation, ready-made materials, as well as traditional materials), all address issues of spiritual dimensions, memory, and the body, often relating to Cambodia's history, particularly with regard to his childhood recollections of life during the Khmer Rouge period (1975-1979), and its people and culture, both its ancient traditions and contemporary struggles.

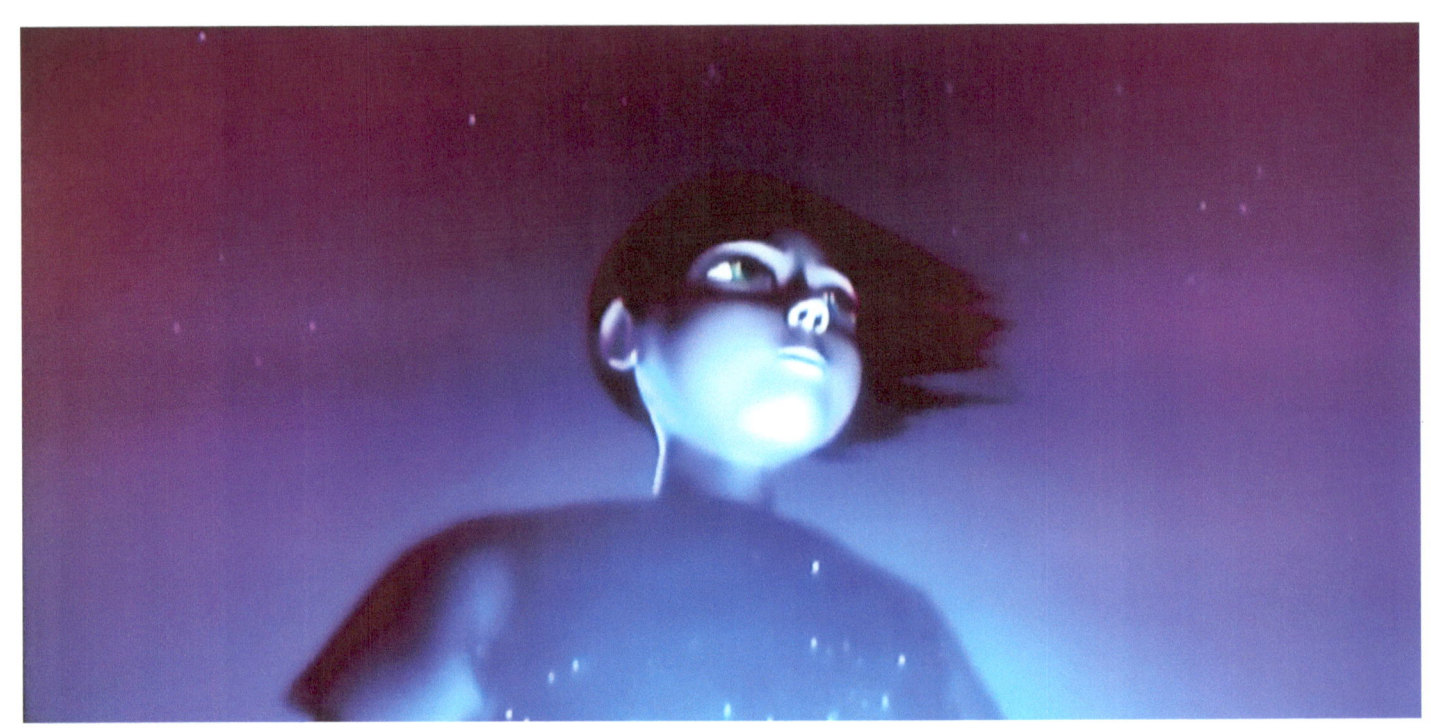

Evan Viera

Caldera
3D Animation
Video Duration 11:23

CALDERA is inspired by my father's struggle with schizoaffective disorder. In states of delusion, my father has danced on the rings of Saturn, spoken with angels, and fled from his demons. He has lived both a fantastical and haunting life, but one that's invisible to the most of us. In our differing understanding of reality, we blindly mandate his medication, assimilate him to our marginalizing culture, and entirely misinterpret him for all he is worth. CALDERA aims to not only venerate my father, but all brilliant minds forged in the haunted depths of psychosis.

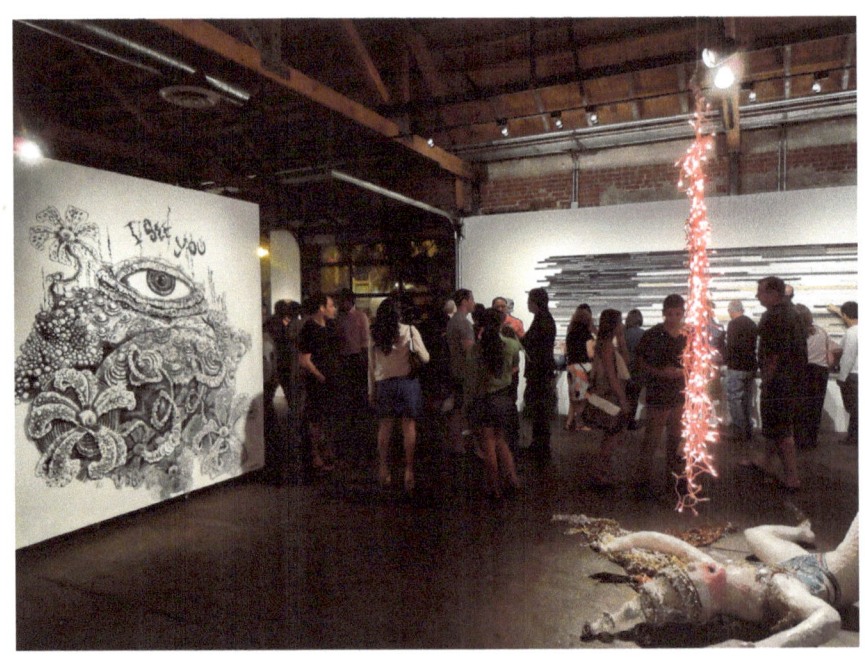

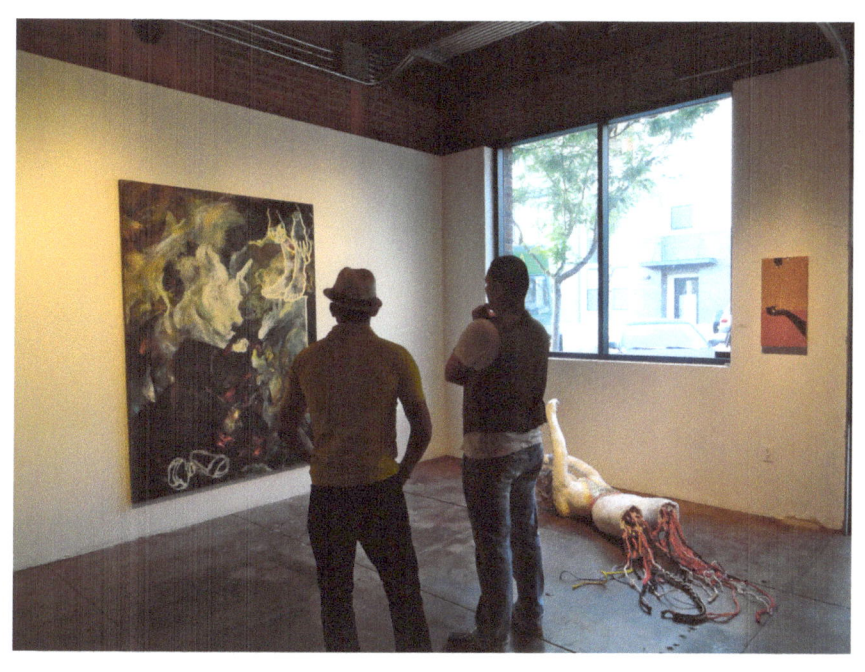

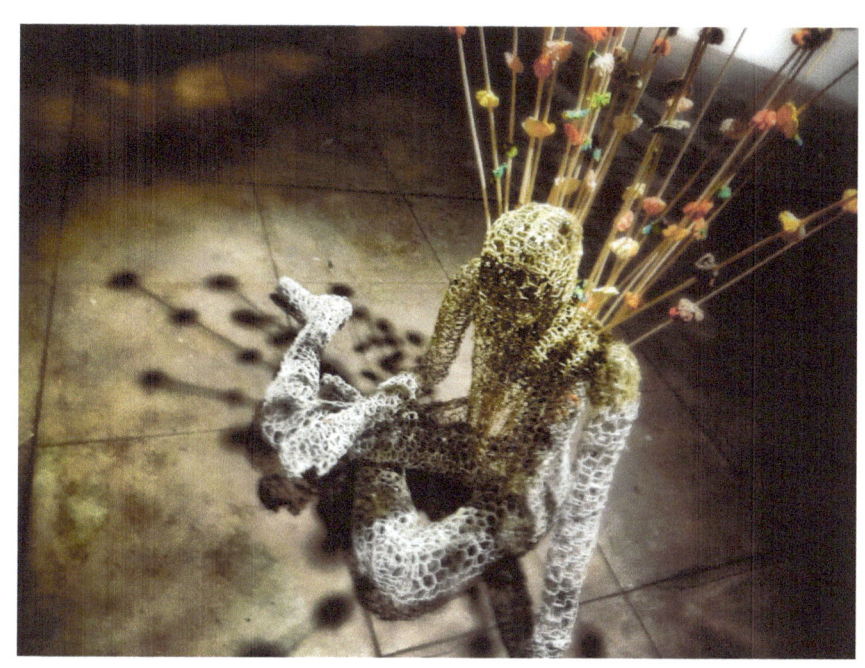

Published On the Occasion of the Exhibition:

"Connect Heal End Stigma"

July 6 - August 17, 2013
Orange County Center *for* Contemporary Art
Santa Ana, California. United States

Curated By Janice Deloof, Jeff Alu & Joella March

Funded by the County of Orange Health Care Agency, Behavioral Health Services, Prevention and Intervention Division, Mental Health Services Act /Prop. 63

OCCCA Administration, 2013:
Executive Director: Stephen Anderson
Assistant Director: Jeffrey Frisch
Exhibitions Director: Jeff Alu
Treasurer: Christina Ponce
Secretary: Robin Repp

Advisory board:
Chair: Stephen Anderson
Amy Grimm
Sali Heraldez
Katheren Huntoon
David Michael Lee
Joella March
Jon Webb
Kevin Wilkeson

Design: Stephen Anderson; www.MixedMediaExpressions.com
Cover Design: Stephen Anderson

© 2013 Orange County Center *for* Contemporary Art

117 N. Sycamore, Santa Ana, CA 92701
714.667.1517 • www.occca.org

www.ingramcontent.com/pod-product-compliance
Lightning Source LLC
Chambersburg PA
CBHW050819180526
45159CB00004B/1723